# NAKED PICTURES

Bob —
Thank you for all your words out there in our shared world.

Paulette x

# NAKED PICTURES

*Paulette Dubé*

Winnipeg

Naked Pictures

Copyright © 2024 Paulette Dubé

Design and layout by Lucas c Pauls and M. C. Joudrey.

Published by At Bay Press May 2024.

All rights reserved. The use of any part of this publication, reproduced, transmitted in any form or by any means electronic, mechanical, photocopying, recording or otherwise, or stored in a retrieval system without prior written consent of the publisher or in the case of photocopying or other reprographic copying, license from the Canadian Copyright Licensing Agency-is an infringement of the copyright law.

No portion of this work may be reproduced without express written permission from At Bay Press.

Library and Archives Canada cataloguing in publication is available upon request.

ISBN 978-1-998779-38-3

Printed and bound in Canada.

This book is printed on acid free paper that is 100% recycled ancient forest friendly (100% post-consumer recycled).

First Edition

10 9 8 7 6 5 4 3 2 1

atbaypress.com

Whenever we touch nature, we get clean. People who have got dirty through too much civilisation take a walk in the woods, or a bath in the sea. Entering the unconscious, entering yourself through dreams, is touching nature from the inside and this is the same thing, things are put right again.

- CARL JUNG

**Dear reader,**

you are holding a field-photo journal – poetry as translated observations from the field and photos pretty much out of camera and therefore "naked".

At the start of the Covid-19 pandemic and during the subsequent break down of many of our given social structures, days melted into each other, appointments, schedules and routines were gone. We lived from one screaming headline to the next, from one restriction and revelation to the next. The world tick-tocked between hubris and helplessness.

The discipline of walking 7 km per day, taking photos, then coming home and describing what I saw, gave me a sense of purpose and responsibility. Those walks yielded moments of solace and balm for a brain too full and a heart slightly battered.

*Naked Pictures*, became both reminder and reassurance that we not a part from nature, but a part of it. It became

abundantly clear that life will morph, and so naturally, after a few months, my perception and my writing morphed. The descriptions and observations of my environment became translations of what I saw, then lessons I could apply to my situation and ultimately, medicines that I took in and grew from.

I came away from the year(s) 2020-2021 knowing that my relationships with the land and my loved ones are the things that keep me sane and curious.

Are curiosity and relationships two eyes on the same beast? I think so. That beast, *Naked Pictures*, is what you hold in your hands.

# Naked Pictures

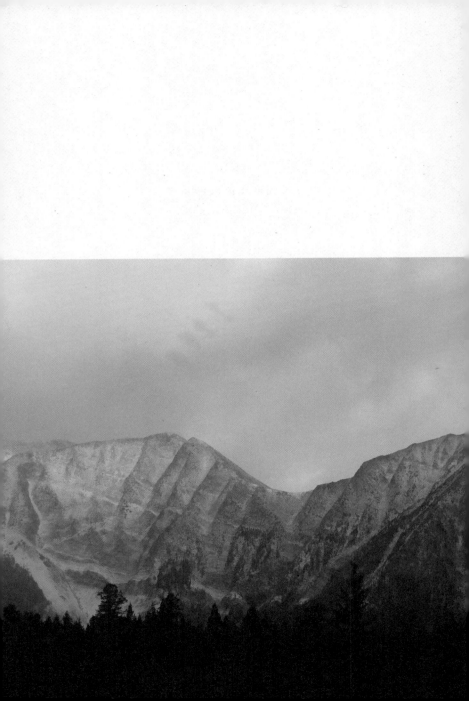

the light was just starting as we
(Raymond glided, I shuffled)
skied over Pyramid Lake
pick a direction – blue sky there
cloudy and windy here

it was as though you could decide
what to see
almost like you had the choice
of how you were going to feel

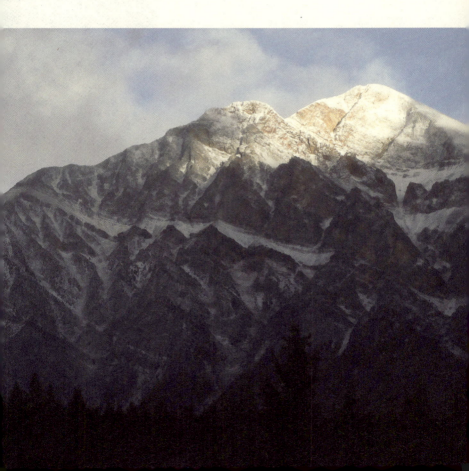

The elk we named Buick
reads the sign
promising medicine.
He reckons he needs an appointment.
Later, he tries climbing
up onto the front porch.

His rack is far too wide
and he probably doesn't need
the medicine we have here.

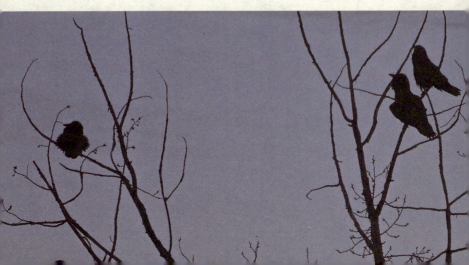

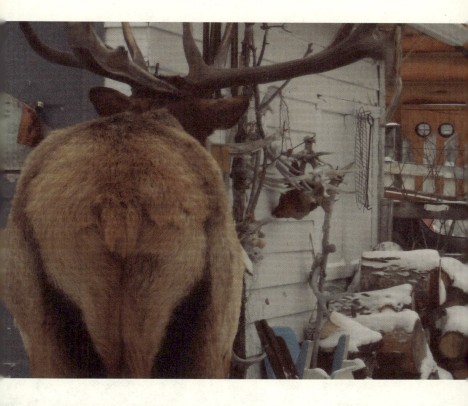

As I settle into the crunch of snow
Raven says hello, I follow him
to the tree where two other ravens wait.
We all look east, moments pass
clouds smooth out; sun
stretches, rolls and rises, rinsed in gold.

There is a high-pitched humming, a tight
thrumming coming from Earth's work being done.

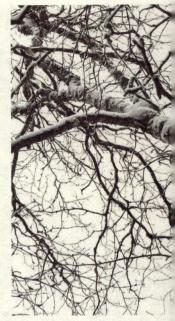

Looking up I see how the crown
of trees supports the snow
and below, how branches
reach out, hold the snow.

Maybe this is where life starts to make
sense, if I stop trying
everything flows a little easier.
A taut rope vs a twisted one. Branches
and snow.

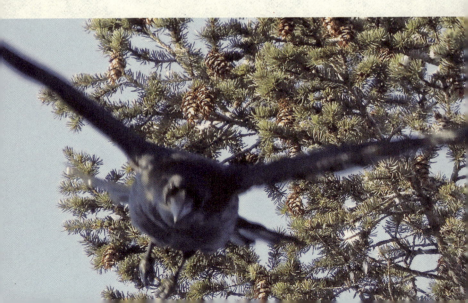

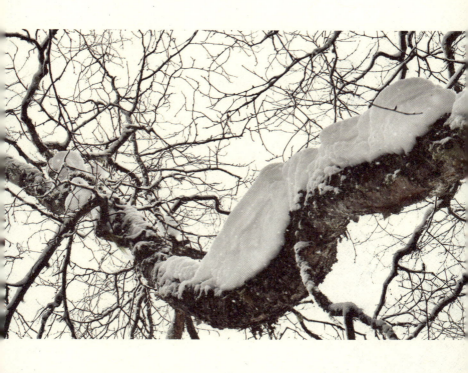

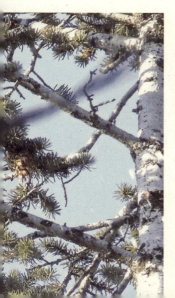

All along the Bench,
on trail 2A
denizens watched the parade
of fantastic sunlight on snow
flights of forgiveness and curiosity.

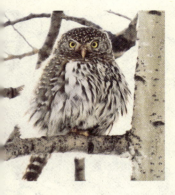

Pygmy owl &lt;Glaucidium californicum&gt;

What was I thinking about before I saw you?
I can't remember, now
the world is the size of a pygmy owl.
Your Latin name anchors you.

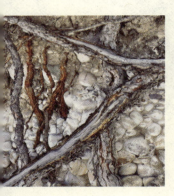

Along the bank of the Athabasca
there is perspective: roots
in stark relief shout
how much we need to be grounded.
When the earth is degraded,
it all becomes a bit shifty.

Medicine Lake is all I need:
the sound of running water
at -21 C is music.
There are other mountains in the world
there is other snow. Here there's enough
blue sky to break your heart.
Here there's medicine
to put your heart back together.

A general meeting was called
to order the world.
Your absence was the place
our eyes went to
every time the door opened,
our hearts lifted.
We drank coffee and flung ourselves
into early morning expectations.
There is so much order to restore.

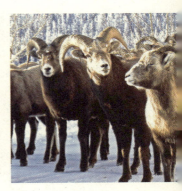

water as sheen on ice
the changing bark of trees
sunburst lichen defying snow
brought me to my knees

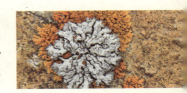

Seven Steller's Jay on the lilac bush
and I don't care, but
that bitchy greywind has been ruffling
some feathers for more than 24 hours straight
(and she had the nerve to bring
her idiot cousin, Snow, who never seems
to take the hint to leave).

We have no cardinals here
to signal the souls of the dead.

I'll take seven jays and name
them for those gone.

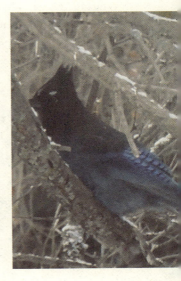

I write fan letters.
Jane Siberry, Garth Brooks, k.d. Lang,
Alan Doyle, have all had the pleasure
of my notes. Only one person has
ever written back. Timothy Findley. Yes,
The. Timothy. Findley. That one.

Raymond gifted me, Inside Memory - pages from a writer's workbook, and I took it upon myself to congratulate Mr. Findley on this incredible piece of work, along with all his other incredible pieces of work. I told him that I was grateful for his words in the world, and continued to ramble on at length apropos of nothing for quite some time.

I figured he would never see the letter (don't People have people for that?)

His reply was professional, gracious and typed by his partner The. William. Whitehead. I read it over and over, 100 times. All I could think of was how marvellous it was that he had actually held that piece of paper, had put his magical pen to that page, signed his name, had maybe even said my name out loud, in passing.

FINDLEY / WHITEHEAD
QUA. BAUQUIERE
83570 COTIQNAC
FRANCE

I don't know about you, but I believe in charms and magic. That letter was a charm for me.

On and off for the next few years, until his death in 2002, we exchanged news and little gifts, as circumstances and serendipitous opportunities drew us together. I was there for him when Bill was operated on, and he was there for me when I needed "a blurb from someone famous". I felt terrible asking him, but who do you ask when you live, literally and figuratively, a million light years away from famous authors--let alone anyone in the publishing world?

Of course, I thought that would be the end of our penfriendship, but of course, he acquiesced.

So.
Write letters.
Write love notes.
Write to old relatives and lost dogs.
Write fan letters. The bridges between people are the relationships that will save us.

Question this week: how do I learn to not put stock in people's opinions or rejections of me and my work after thirty years of being judged every hour sometimes twenty-five times an hour?

What I heard from my teachers this week: discipline is remembering what you want.

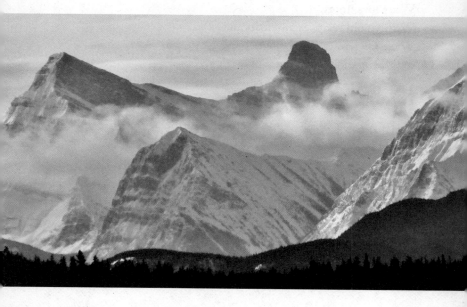

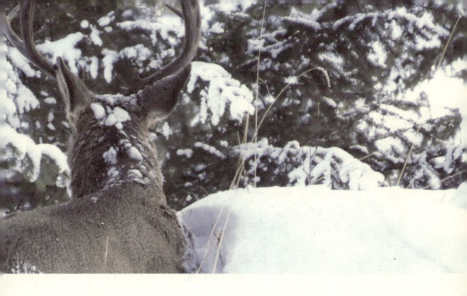

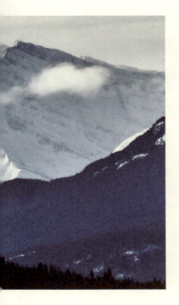

I'm driving along in my skin suit
and realise that the challenge ahead
is to sustain this idea of falling
in love. Right now, *I am oooooh! So exciting!
This is such a challenge!*

I can make poetry and cookies and
be creative and passionate, vociferous,
anxious and giddy and extreme and
compassionate and empathetic and joy
filled and and tomorrow, I will need to
do it again.

So, it's good that I am not so much
a race car driver as a long-haul trucker.

This morning, I witness
heart wrenching vistas of cloud, light, mountains.
It seemed too intimate, too strong, too much.

Relaxing into it seemed impossible
ignoring it would have been a sin.

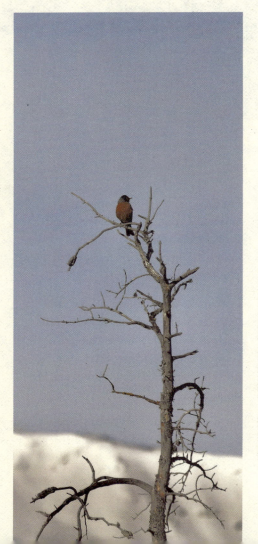

there is a beginning to every end
André asks: *Are you guys ok?*
*Can we come home?*

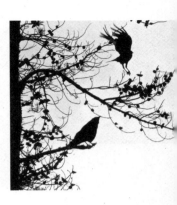

What is it called
when you see an animal in the wild?
What peptide acid is launched?
My heart softens, as though
I have been chosen.

I trespass on their sleep, on their forage,
they ignore me, they tame me.

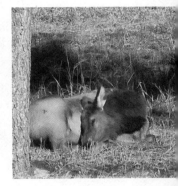

The morning cloud,
the red-capped thingy sparrow, the bear,
the new riverlet down the fire road
none of them paid any mind
to the world.

The business of life is not busy-ness, it is
the roar of the engine of life, it sounds
like the river, now released, surging
and seeking her true bed.

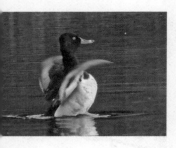

My sisters are birds.
Floating on the miracle of absence
they abandon land for travel
better suited
to feet without nerves
and are content with both the price
and the prize.

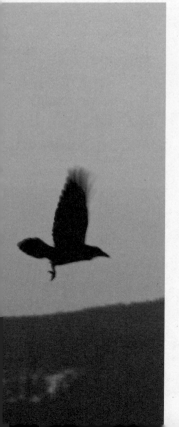

I am not competitive, I am comparative.
(in honour of Sophie Faber)

Mirror, mirror
piece of glass, broken as a mountain.
My eye a moth wing
sweeping over grass
water leaves shadows.

Once more on Earth
mirrored pieces of heaven move.

Usually, I plant carrots in a long dry riverbed
but this year
many trees were cut down
trail 8 was drained of her sloughy goodness
the snow melt had no roots to hold her
so, the river rushed over my carrots,
washing them to the ditch by the highway.
So it goes. I will plant something else,
another place, another time.

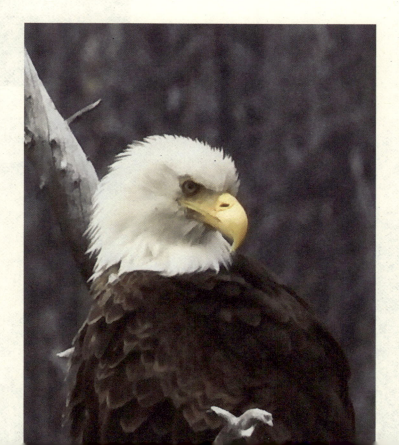

Strange how we can begin again everyday
good intentions and piety after a binge
are refreshing and resetting.

There is this grass elegant,
whip thin line where I walk
a hair on which I balance between
being a monk and being a drunk.

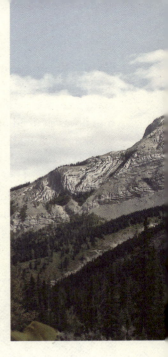

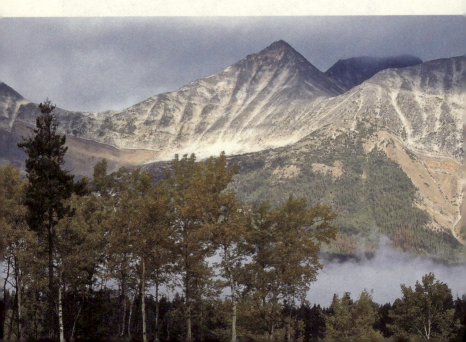

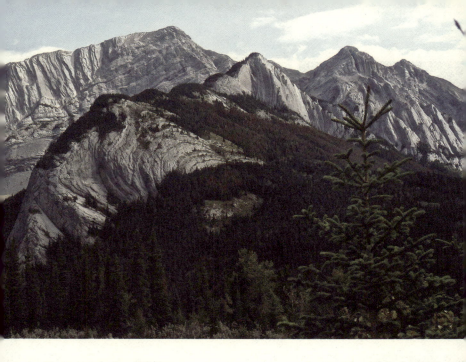

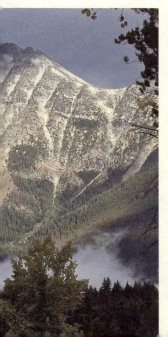

Make a mountain,
put it exactly in the way; how
people react will tell you
everything about them.

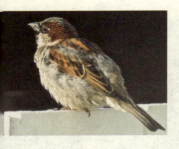

Washing windows, about that –
two people look at the same
window and see
something different.

Outside triumphs over inside.
When rain falls, inside you manage.
Outside does whatever the hell it wants.

The fire road is a busy place
things surge, struggle, wriggle, saunter
and wander.
We are not all in the same boat
despite sharing the weather.

Pussy willow blooms
two Canada geese, seamless
in the slough -
strength of place can't be denied.
Spring simply carries us.

Walked to the post office after supper. Two deer strolling, browsing. No sirens. No screaming drunks. No smoke from any fires. No racing cars. No litter. Just the song of birds.

(no photo no need)

So far have we fallen, so too shall we rise.

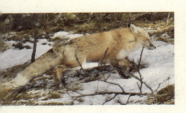

Full moon, approach
with caution, as if the veil
splits fire from water
holds both space and earth.
Full moon fuckery is coming.

Me: I feel like I'm splitting in half.
She: That's why your back is sore.
Me: Did I rip a muscle back there?
She: You're trying to keep together what
needs to split. That's not muscle
that's scar tissue.

if I could explain rhubarb
I would understand so much more

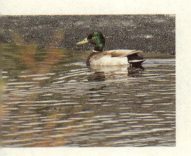

Every morning this week
a mallard paddled along the fire road,
in the ditch.
It is water and he is duck,
so a deal was struck
to satisfy this evolving adaptation
revolution.

*More!* she shouts and plucks
the thing from the air
*No more!* she pinches the air shut

stories live because we tell them to(o)

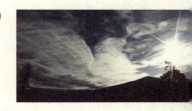

breathe in and out

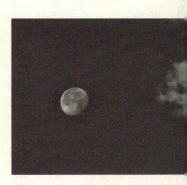

it is difficult to sleep
when so many are awake

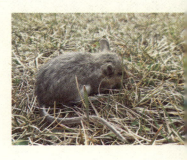

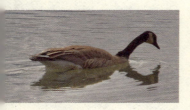

advice from a goose:
*if you can't remember being
held by your mother
find a dry tussock in the
middle of the slough*

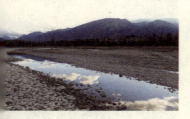

it isn't so much
what you stand for anymore
it's where you stand still

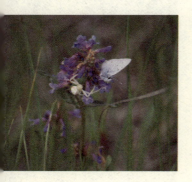

spider season creates opportunity

The weight of snowflakes held
by a spider web
may that also be
the condition of our successes.

chitinous creepy crawlies,
shale, scale and snow
wings, beak, light and
water

The forest holds the ache
and perfume of water,
galbanum, poplar resin,
spikenard and graveyard dirt.

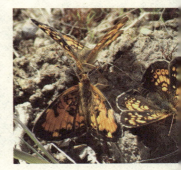

Maybe a language
without verbs would eliminate
power struggles. I nominate nouns:
raven, orchid, sunlight, tree,
leaf, warmth, dirt, balsam, wind,
cloud, feathers, water, peace.

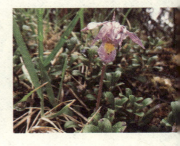

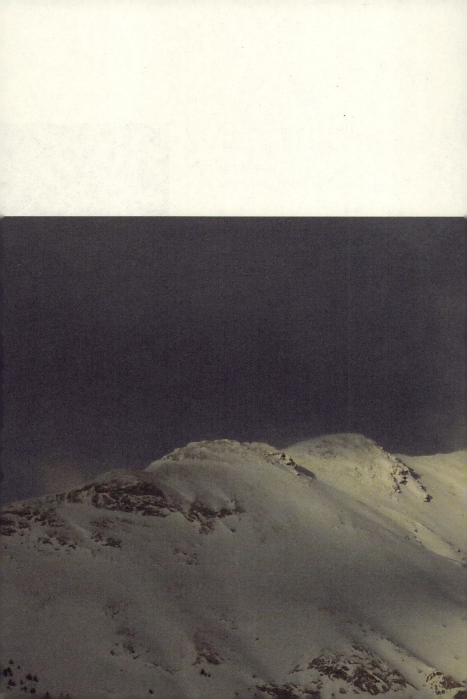

Without people, this would be as sweet, nonetheless
I wonder if my absence would be remarkable? Would Goose
miss having her photo taken? Would Mallard
pine if I didn't call softly with my father's song?
Would Spider linger, wave her legs and wonder
at the absence of my coffee scent?
Would Tree refuse to shine if I didn't encourage them?

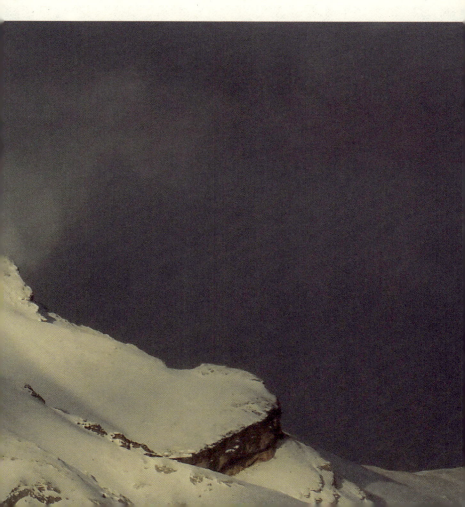

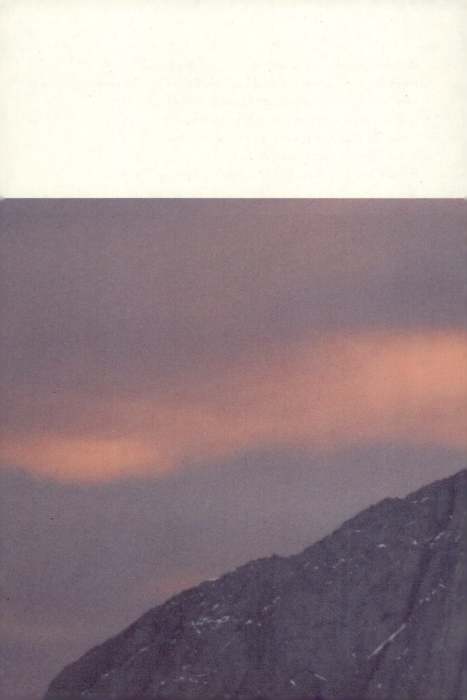

Do elk tire
of growing new antlers each year?
Do squirrels tire of their chase and pine cone stashing?
Does water grow too weary to flow?

Sweet rain, up high,
simply becomes something else.

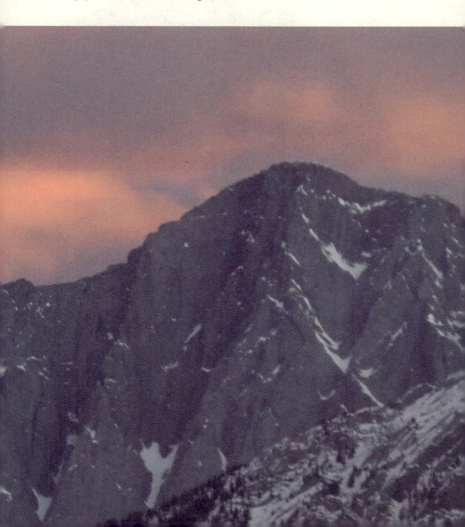

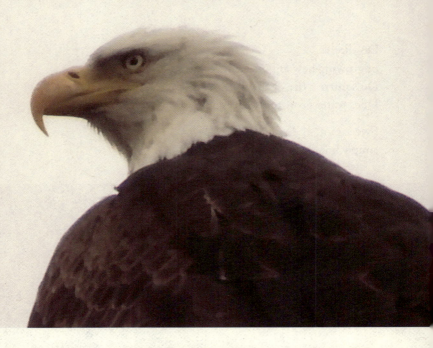

Where fish live, a dangerous place
a place in danger.
The dance is forever.

roll
or if you are a creek
rise

nemophilas
biophilia

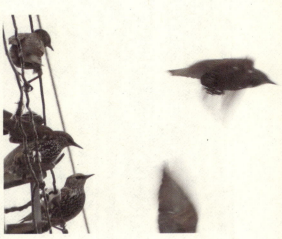

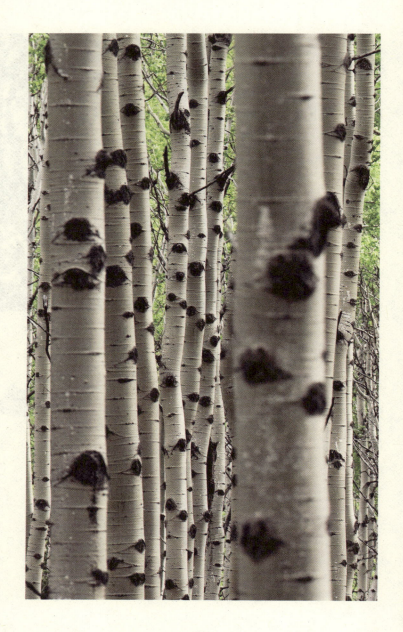

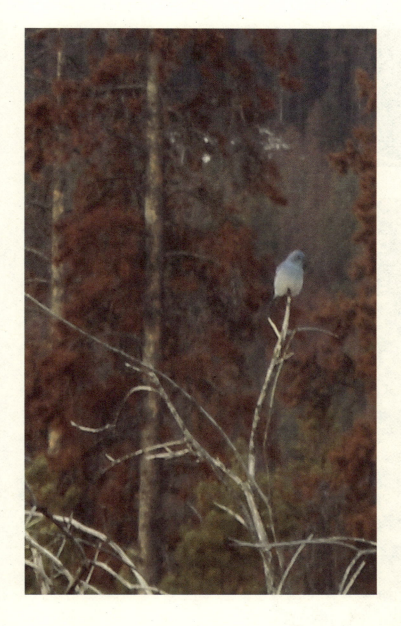

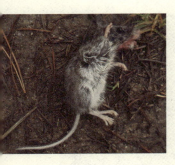

death is the instant
clutch becomes curl

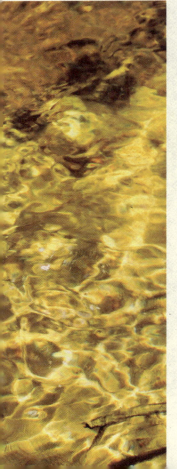

My friend is surrounded
by salt water in New Zealand.
Water tables, tides, flooding
hurricanes and earthquakes
are her neighbours.

The sweet water of
Cottonwood Creek is offered
here, on the zoom screen where we work.
Vivienne looks at me
eyes brimming with salt water
and drinks.

Did anyone leave the light on
for the creepy crawly
who slept in the rose last night?
Was she called for?
Did another fill her sleep space
with worried pacing?
Is there a light still burning for her?

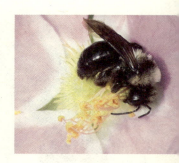

trees wait for us, growing
in bark and leaf, leaving

Aspen eyes keep watch
as humans stumble around
build walls, forge swords,
stake claim, rights.

Imagine their laughter,
*there they go, at it again!*

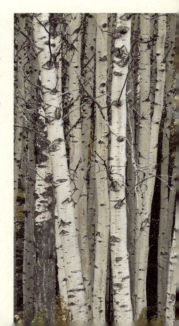

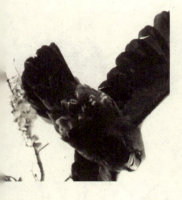

When I was a child, a sharp
gurguggly feeling
in my stomach preceded storms.
I knew to wish upon a star, blow
dandelion fluff,
knock on wood, avoid
cracks in everything
to keep the monster from coming.

I still light candles against the dark.

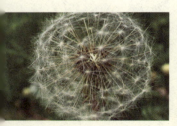

between sky and river
a world I'm hardly a part of

I am grateful for maps.

From the north comes a zephyr,
meanwhile, creek water roils.

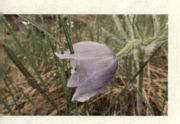

bring your grass swords
your harbours of green leaves
bring on your lavender lipped flowers

I have just the sack

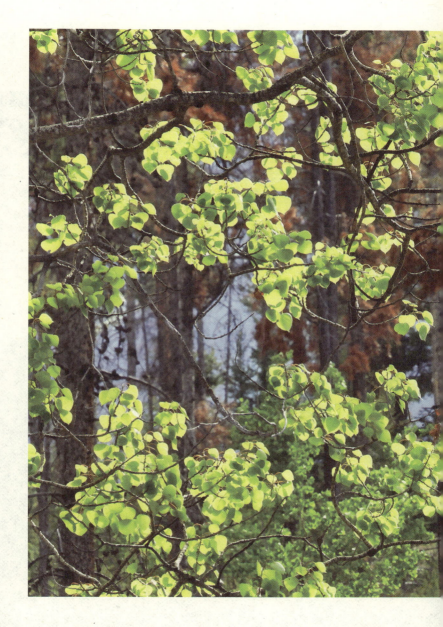

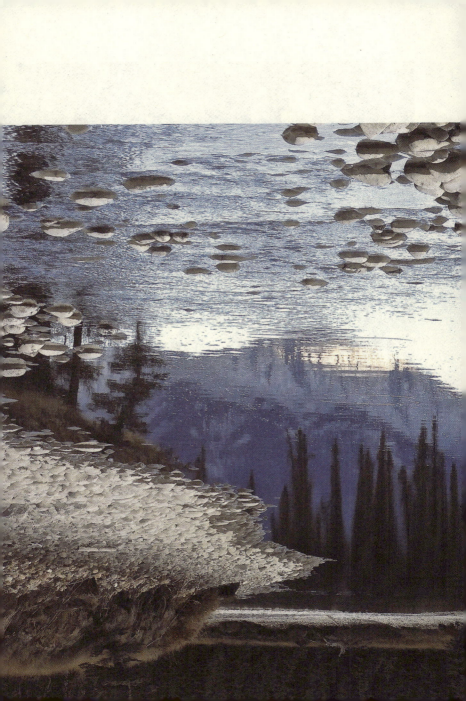

if it doesn't come up on your radar
you need a mirror

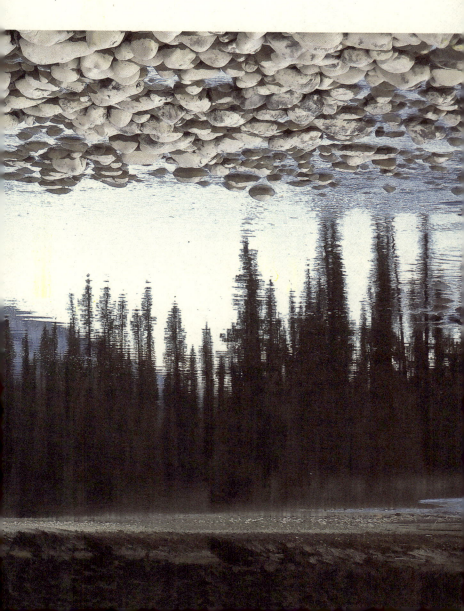

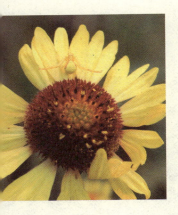

yoga studio for spiders
no mad elk
no wandering grizzly

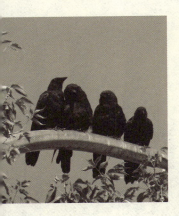

Earth's laws
must be (l)earned

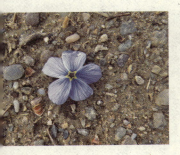

I've learned that people are like teeth
you take them for granted until they hurt
or fall out, then there is
a hole you can't stop worrying
with your tongue or your mind.

Royalty returns.
The call has sounded, we are to gather
pull ourselves upright. The drunk days are over
the real work begins. Put away swords
throw open the doors.

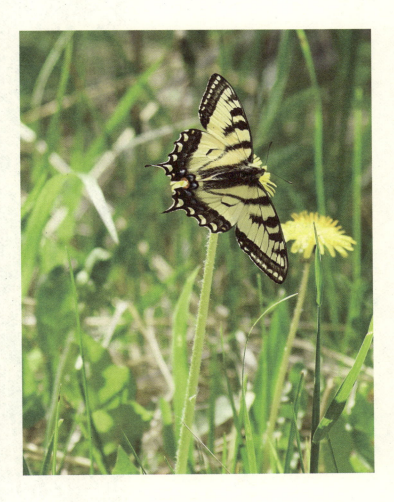

Bruno Albenese, a Spaniard on vacation with his family: Hey? You know what I hearingtoday? I hearing music!
Me: Music?
Him: The trees! No, the wind. No, the wind and the trees. I am looking to the sky for the bird you ask about. Every time the wind blowed, the tree, the tree mades a music. This is magnificent! Every tree, Paulette, I kid you not.
Me: That is pretty amazing.

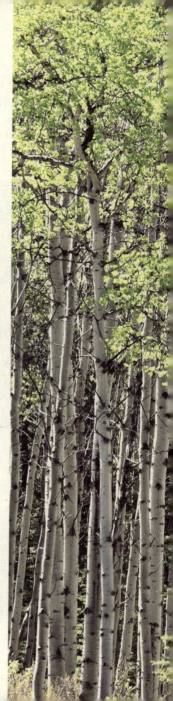

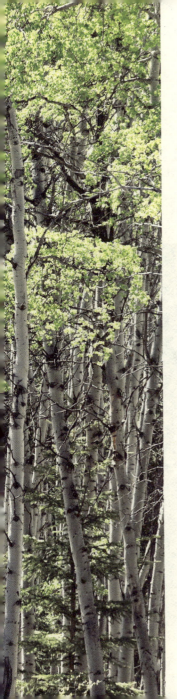

His life was never the same again. Once he returned home to Barcelona, he would often stop at a small stand of trees, carefully planted in parks or along boulevards. He would stand beneath them "hearing for music" again. It never failed to thrill and calm him. If this truth eluded him for so long, what else was out there that he knew nothing about?

now seems as good a time as any
to stop a lot
mostly look around
kneel
listen
learn
live and read between the stone and the sweet
between the strong sweep
of stone and the language of the sweet

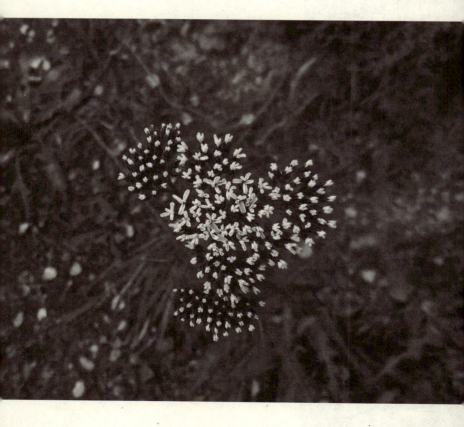

by June the world's words
the speeches, proclamations, the data
sound like so much mud

I turn to what I see
to be real
the journal takes on a new shape – form first,
then an interpretation of sorts

I become a somewhat or a kind of translator

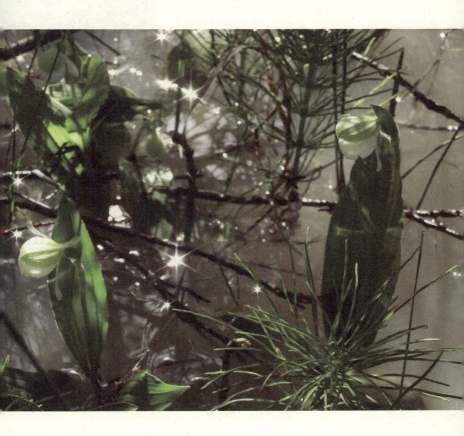

this is how it begins: water
then gravity and music

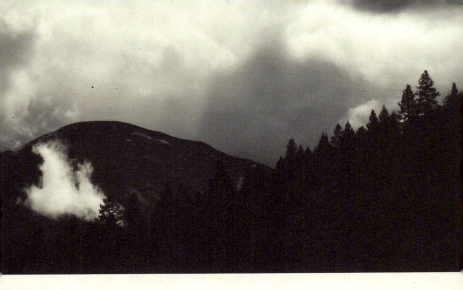

How to make a whale from scratch –

Pull open your skin suit and stuff
as many stars in there as you can,
also a sturdy wooden spoon.

Bury a femur (or what? a tail bone?
a leg bone? what do whales have hidden
in their bodies?) with the teeth of twelve
snails beside the wall you have chosen.
In the morning, there will be
a baby whale resting there.
They can't show up on land fully grown,
that would be silly

(There are no photos of this,
whales on land are quite shy)

How to call a whale –

Put you ear next to a wall
the Library of Alexandria say, or the Wailing Wall in Jerusalem
that Douglas fir on the ridge will do.
Put your arms around an elk and
bury your face in her flank if that's all you have.

Pretend you are walking on tiptoe, stoop
practise rumbling your spleen and liver
until you wander salty as tears,
filled with krill and your mother's face
the woman who could cut an apple in the palm of her hand
knew all the important phone numbers by heart.

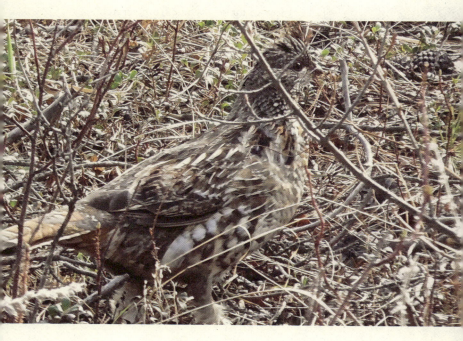

eat mountains, regurgitate light

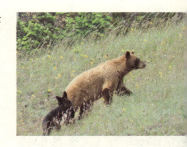

If there is time, I'd like to write
as many love poems as possible
to butterfly, flower, bee, and spider.

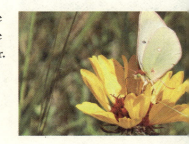

Medicine Lake
for scale, the shore is 50 feet below
the waterline rose and covered everything
it's happened before

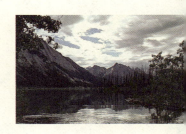

grass is Creator's band aid
people, rocks and wounds are extra

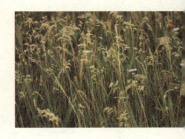

Camouflage is not hidden or hiding
it's blending in, being a part of.

Some will see clouds covering
the mountain, others see
the mountain coming
out from behind the cloud.

Neighbourhood teenagers
hold sky in one eye and water in the other.

We were wicked when we were young
brash, adventurous, ferocious.
We did what we wanted, how we wanted.

Now you cut the grass, while
I hang laundry to dry.
A hummingbird flits over
to taste this sweetness.

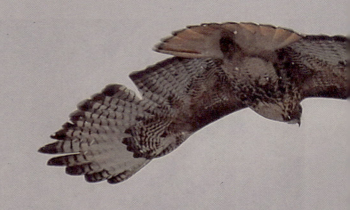

She shows up: *if you want to eat, you have to hunt.*
Follow the map of the world on her belly.

As they fly unbearably high overhead
loons make the loneliest sound.

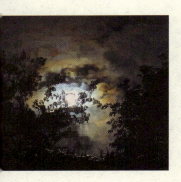

When I am heavy with fear
or anxiety, I am too dense to hear.
Walking thins me. Truth is
whispered by stones over water.

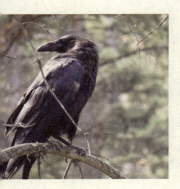

Some days I need family.
I need my name safe in their mouths.
I need to fill up on their touch,
soft as river tossed stone.
"My people" is a complete meal.

Summer people come to the mountains
rabid, and angry.
Despair and worldsized confusion keep
the highway ablaze
with semi-truck wrecks
spilled fuel and diapers flung from hot cars.

We will build the next world from bones
broken and blood spilled
until then, this from my friend Sandy:
*Once a week, get above the treeline; it will
remind you of how small you are.*

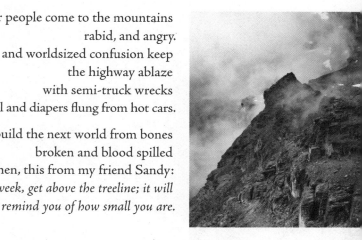

flipping any scene 180 degrees reveals
a turn of events, where the reflection is
almost as clear as the physical

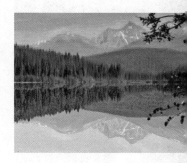

Mouse staggers between yarrow stalks
buffalo berries barely bend
little mange-riddled body
shudders and twitches.
He cleans his face over and over.
A bee dies on the clover in our yard.
Another bee sleeps upside
down on the rose by the gate.

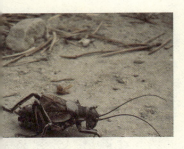

Almost
a shadow
the great grig as samurai.

yarrow speaks root language
appears to teach
*gowan whit 'ye, sure yer strong enough*

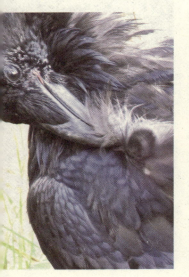

Some moments stick
for being unbelievably weird

Covid-19 cases climb by the hundreds
schools reopen
Parliament is prorogued
an ice cream shop worker
an ice cream shop worker is harmed
over the size of spoon given
as a free taster.

…but he is my son – I say
*And he is our child* – They say.
*Rest easier. Breathe.*

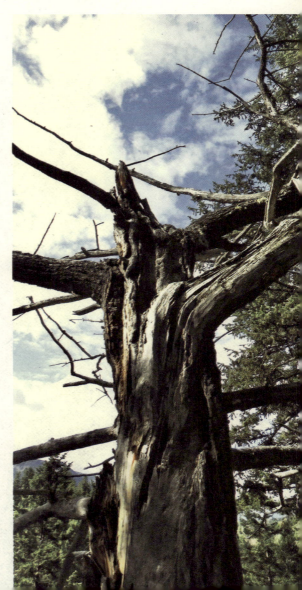

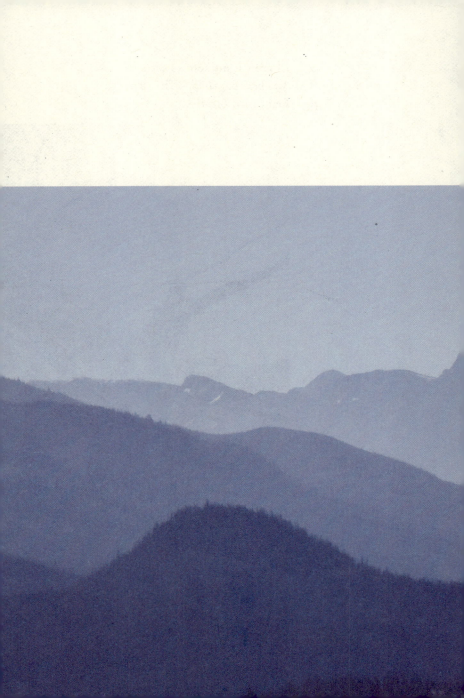

The first magics - water, earth, atmosphere - created
two different types of bacteria
heterotrophic and autotrophic, the first was a consumer
the second a producer.

Anthropocene – heavy on heterotrophic tendencies
how is that for evolution?

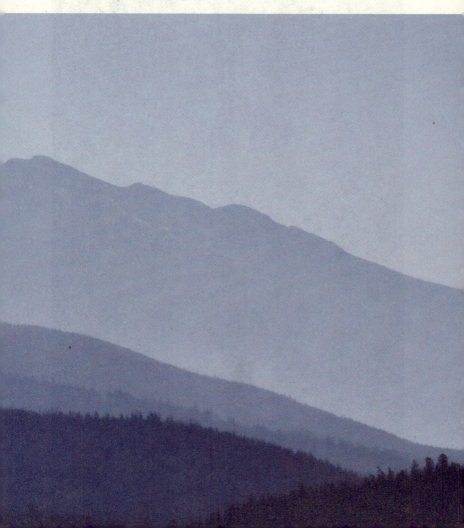

We need Earth as respite.
We need to be part of something that requires nothing from us
something ultimately and subsequently, better at fixing itself.

in conversation with Dr. Magnus Stenlund, on the Bench trail

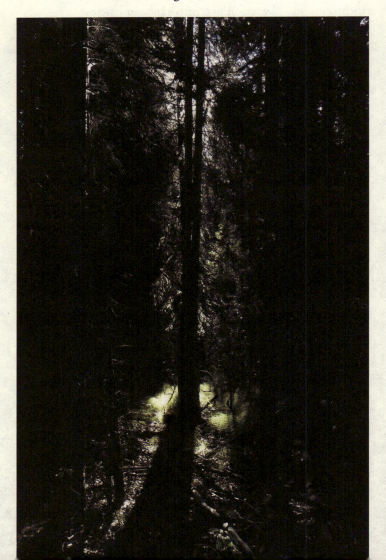

can I share a secret?
red tail hawks do not care about you
creeks will flow whether you are
there or not

awareness of self
and recognition of other
exists naturally

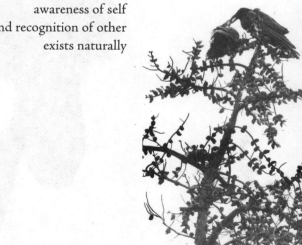

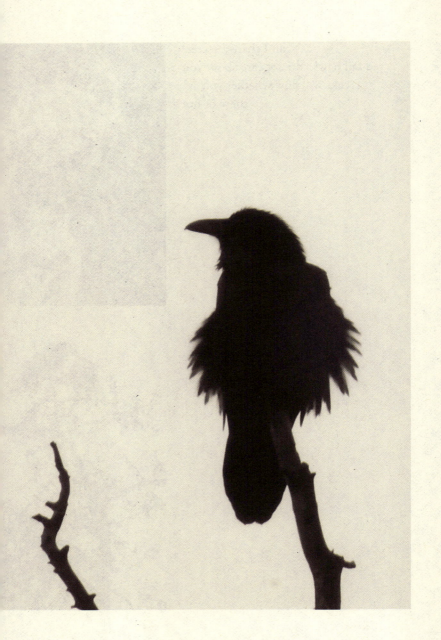

as the body dies, fruit appears

Wind NNE strong
four sunflowers have bloomed.

We need more bleach and I have
set out the knives, to be sharpened.

And what will we apply to the skin today,
sword or salve?

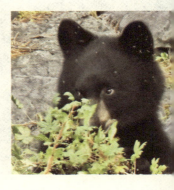

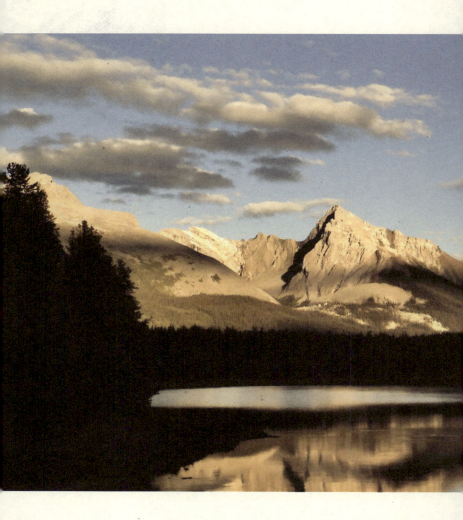

The long and shore of it –
turn the world upside down, if it works, it works.
In a month or so, fires in the United States
won't bother Canadians anymore.

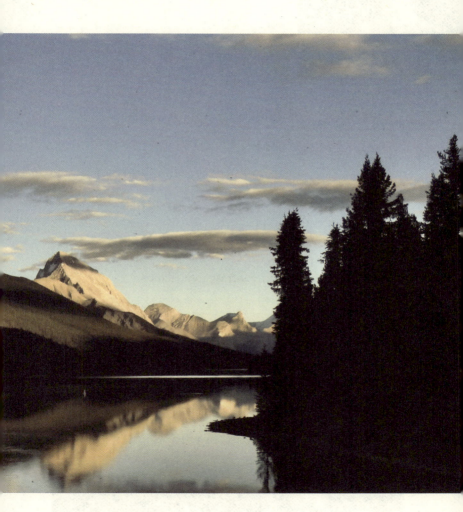

Are we not also of nature? Our flaws are us.
Maybe I won't scrub so hard.

become as perfect as a duck

I choose Earth
a damned fierce place
surfeit of colour, humour, contrast and balance.

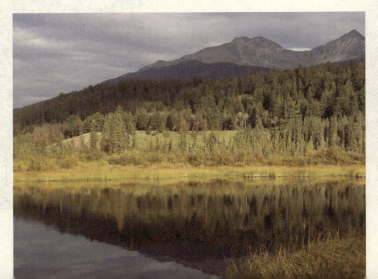

Forecast was for rain
went to the Fiddle River anyway.
The rocks were tricksy and slippery
ambled anyway.
The river water was sweet and cold.

invocation for peace

a small place
made of wind, stone and wood
alive as promise, a map of the past

I'm going now
as surely as the snowline appears in early morning
I'm hanging up my shield, it served the war
and this is not war. Now is the dream coming
as implacable as a snowline in early morning.

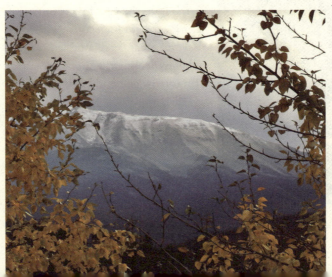

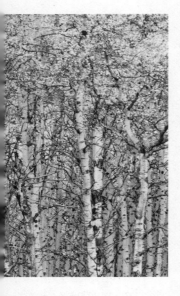

orange shirts in Canada
black hair, braided and kissed

orange man in a white house telling
proud boys to stand by

Squirrel runs across the road,
mushroom in his mouth
blue sky
yellow aspen in white suits
a flicker
a raven

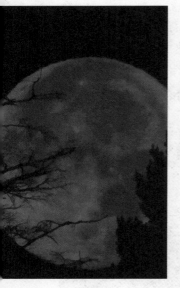

Under the sky
we stand mouth open and eyes wide.
Seed knowledge is floating
around up there
catch it on the tip of your tongue.
Let it settle in fingertips,
beyond what is acceptable
when reflecting the moon.
Tomorrow you will be different.

Of course, as a child I looked up to trees
as an adult, I should remember that.

What else have I forgotten?

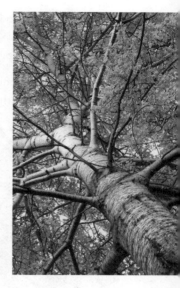

everywhere I put my eyes today, leaves fall
everywhere I put my heart
I am left empty
like a bucket of leaves brought to a tree
I fail to attach to the branches

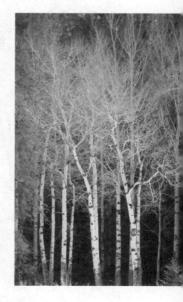

Ravens hang the moon
then wait for the two-legged
to look up and gawp.

They aren't smug about it, this hanging of the moon
it's done every month, but they do appreciate gratitude.

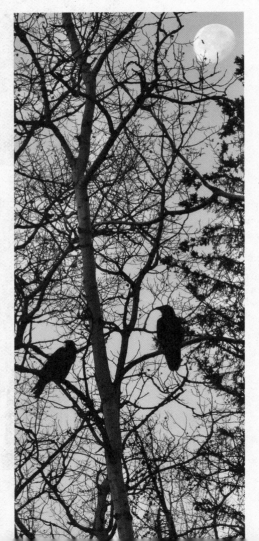

According to legend, if you crack open
an egg and see two yolks, a wish is coming true.
It is the past and the future coming together –

Moreah walks over with gifts of sweetgrass and sage.

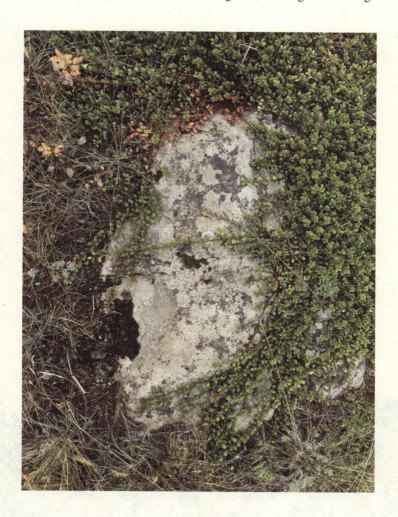

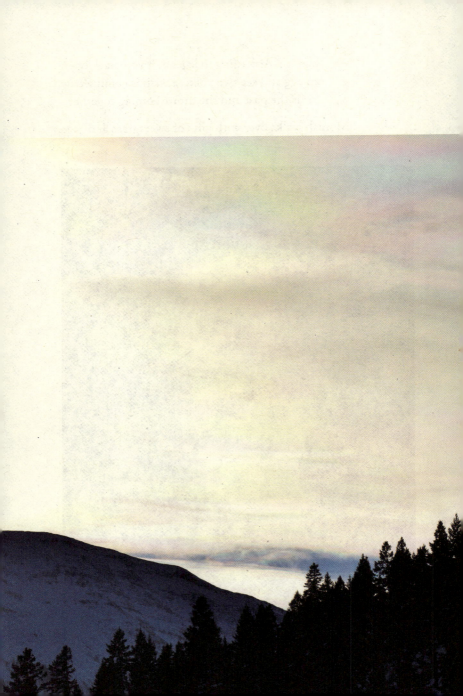

Some see it as orenda.
Some say play of light and shadow.
What counts, is seeing in the first place.

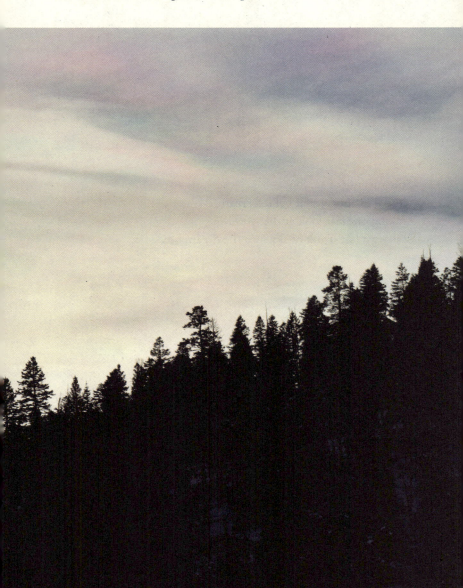

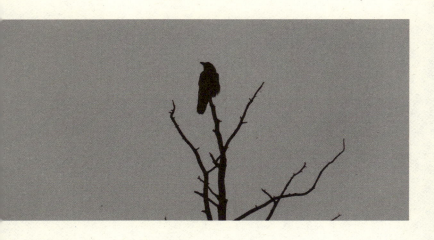

the turning of seasons
like some big old fat bellied creature
taking one last look at the world
taking a last drink of sky into the dream box

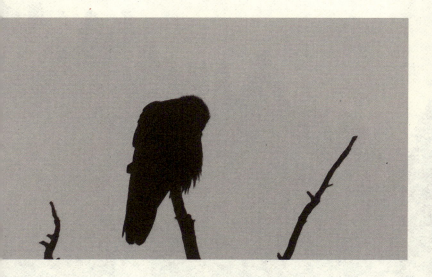

Thanksgiving weekend.
Between the last few months of cacophonous anxiety
and the next few months of cold rain, mist in the trees –
or is it a cloud
caught between worlds? We struggle
to remember The Good.

But it comes, doesn't it?
Yes, it wisps over the smell of wood smoke
turkey roasting, butter on potatoes, the tang
of mountain ash berries. The Good comes.
Sits down at the table with us. Pours herself a good
stiff drink to warm up and tells us the story of her trip here.

It's so hilarious, so unbelievable we keep checking the bottle to see
if she hasn't surreptitiously poured herself more during the telling.

But no, no amount of spirit could have brewed this whopper.

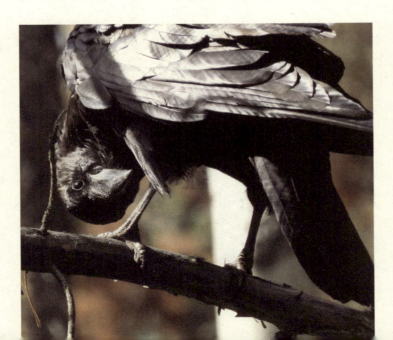

first pandemic themed funeral
my good friend Hywel's mom died and we celebrated her life

Grab a bit of sanitizer for your hands,
wear a mask, sit well spaced – the room is still
hushed, the candles lit, people will cry,
dreaming is not mandatory but implied.

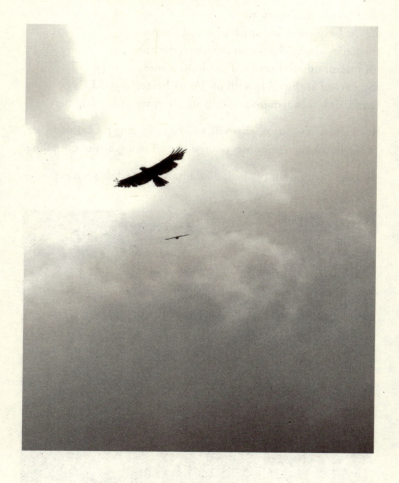

Do only catastrophes breed vocabulary and style?

Will something monstrously good arrive?
Will cataclysmic wonder engulf us?
I want the old god-fashioned flood
of hope and love.
(no photo)

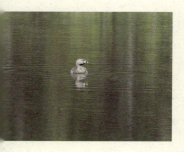

the slough offered no turmoiled emotion
as befits the state of the world
instead, this grebe

Coming home from a walk,
I stumbled, stared into
puddles. The long line of our back alley
had me tripping along, whooping.

Now the wind wakes
and amuses herself
by throwing snow at my window.

One friend has Alzheimer's.
One is worried about the nanobots in the vaccine.
One teaches me about the feather, what medicine
there is from the earth.
One reminds me that we are of the stars
that we glitter in the air.

I grow from crinkles and splatters of gold, sparkling
to a welder's torch, to a lighthouse
to a porch light then here, a candle in the window.

There is this lesson in shadow work.

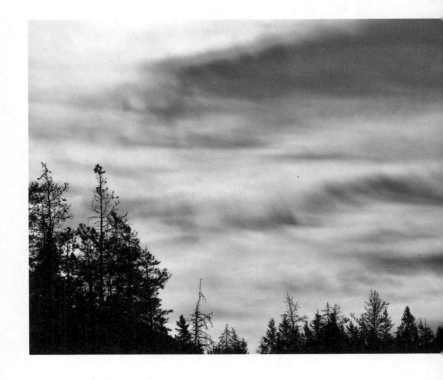

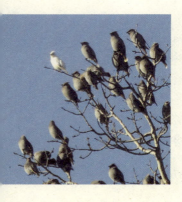

I walk all over this place
as carefully as I can
looking up and down
thrilled at the power of the living

Ice braids land and water,
leaves a window
of opportunity through
which dreams pass.

this place: the mystery
of necessary murmurings, migration
flocks as clocks
cycles as
time

Murmur of the river as she freezes
in pools of sky reflected in rocks so old you
can't remember the last time they weren't here.
Polished faces of mountain peaks and valleys
the sachet of all this, wet
almost warm, might snow, could rain.

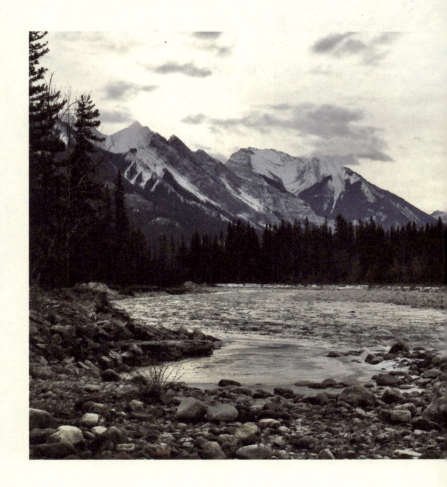

grateful
for beauty

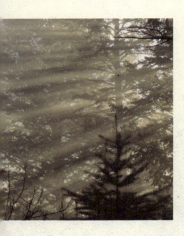

This election stupids me silent
this pandemic mystifies me
this weather terrifies me
(+20C in November).
I pull my family closer
stop shaking long enough
to write in the smoke.

the idea of grass—
to be perennial
even as you disappear

map to the onward, the outward;
mostly mountains
little to no trail

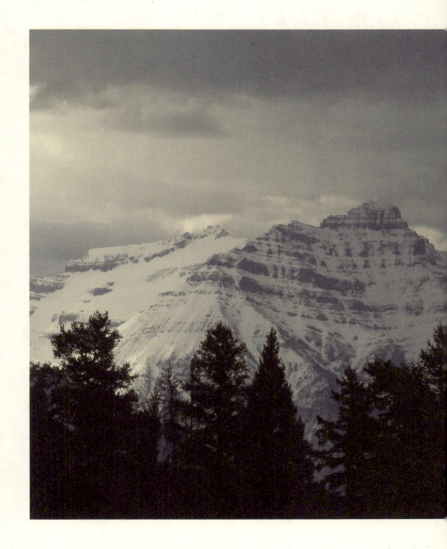

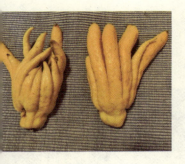

Buddha hands
tentacular, soft lemon
flower perfume
as candy, the rind is useful.

another hand
shows up on the trail

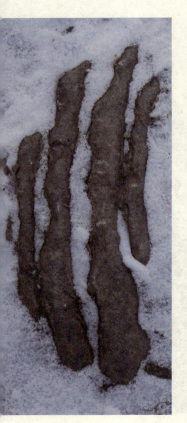

Aspen's black and white
if only everything else were as clear.
There is a strange man in the white house.
He is shouting and now
there are more people around
the house and they are angry.

Second Covid wave
here in Jasper
from zero to 30, just like that.

Raymond scrambles to drive my brother-
in-law into Vancouver
to have knee surgery. To take advantage
of the quick turnaround
before everything
shuts down again.

I go outside, ice reforms on the creek.

Pyramid mountain children
on the slough at her base,
laughing, skating
chasing fish through the ice
envirotherapy

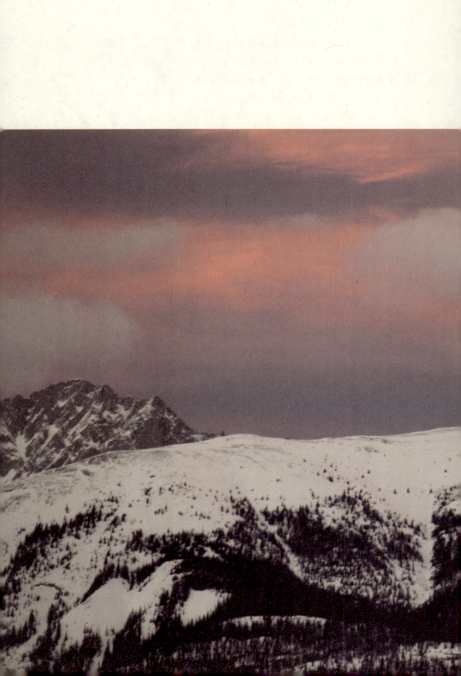

*It is not possible that there is beauty*
*like this in the world*
then I remember
there is a big difference between the world and Earth.

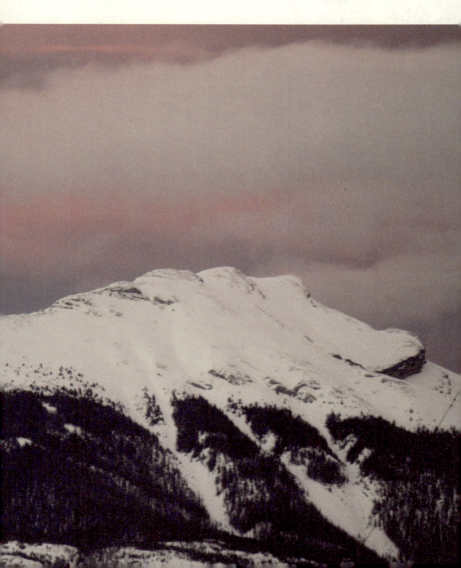

ice knits edge to open

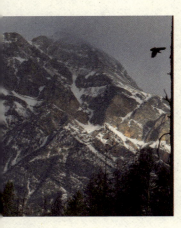

The difference between kith and kin
is the space between wing and wind.

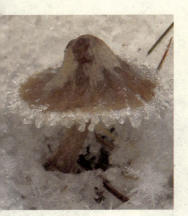

eater of men
wears stars in her hair
worships at no altar

trees heal because they weep

It's been 250 days since the first
fieldphoto walk into this pandemic.
Those days, these walks, strung together
rosary-like; worrying the miseries,
the mysteries
accepting joy, after all.

alone Raven can tell me –
a lone raven can tell me

why consequences feel like punishments

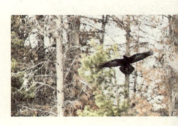

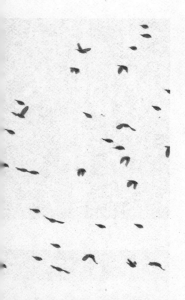

Bohemian waxwings explode
in an ecstasy we cannot begin
to understand. The miraculous
silking of bone, feather and skin.

Water knows its purpose
presents without guile
its slickself
breathing

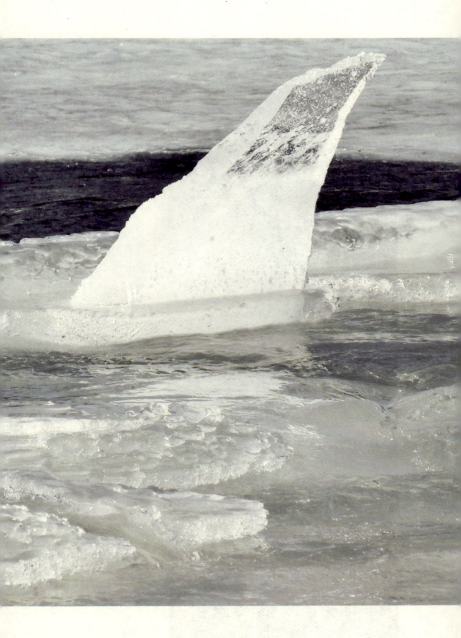

Black stitches white clouds against blue sky.

all this talk about oil exploration
all this hissing coal exploitation
sheaves of paper, man-pens naming
the sections they will carve

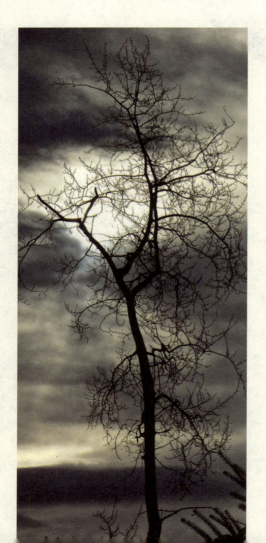

trust the seeds inside you
growing
in sunshine, with rain

Purpose
is to life as wind is to wing.

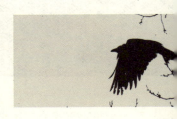

When our son was young, we'd walk
the back alley and run
through the shadow parts yelling:
"Come on Soleil!"

These days too, we run from one sunny
point to the next, yelling like crazy
when we are in shadow.

A searing beauty opened
between dead pine trees and shadow.

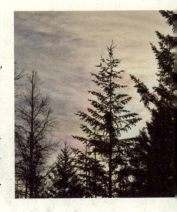

The municipality contracted
a fire smart company to burn
the dead trees. One deer stood
very still until the torches passed.

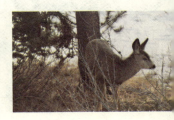

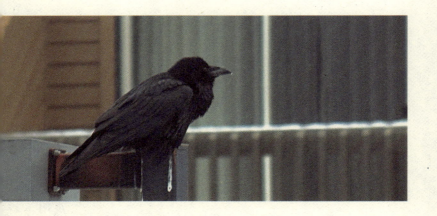

Raven demonstrates breathsong
not easy magic.
Some believe one exhales sweet gold honey.
Some say it is only ever smoky and eel-ish.
It takes the shape of the spell
the form of the thing one is calling.

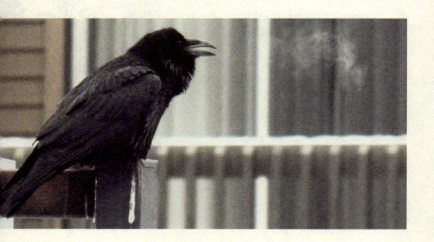

I can't stop thinking about power.
How some think power is
"passed hand to hand"
and how "power rests
in the hand of the wealthy."

A person suspected of witchcraft
was forced to hold a rod of red-hot iron.
If the burn healed quickly,
she was innocent
unless of course she used magic.

The feeling when you see
a Douglas fir pair and their offspring:
belonging.

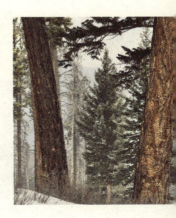

unstuck
long  ache

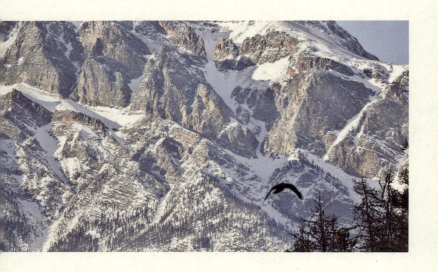

perspective, as in a journey, takes patience
the gaps are measured with onyx oars

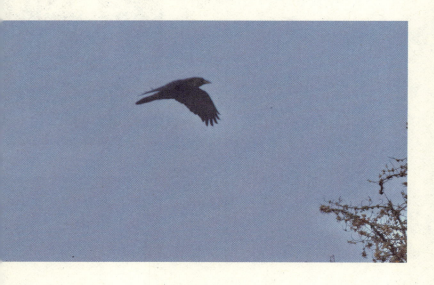

About the heart:
see the rose bush and dried grass
in a hole of ice, under snow.
The rime frost holds inevitable rain.

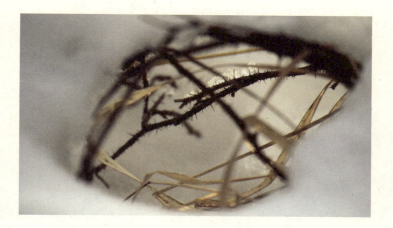

treasure in the creek
what gold, such diamonds

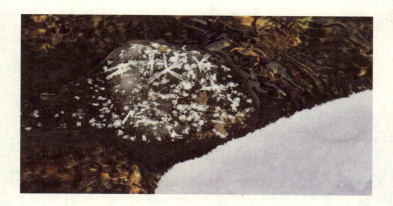

How to call a glacier –

Make a blue whale
put it on top of the mountain
carefully let out all the ego
draw her between the poetic and the primal.

Feed her snow, rain and granite.
Feed her sorrow, surfeit and starvation.
Wipe her down with the moth wing I gave you, wear pearls.

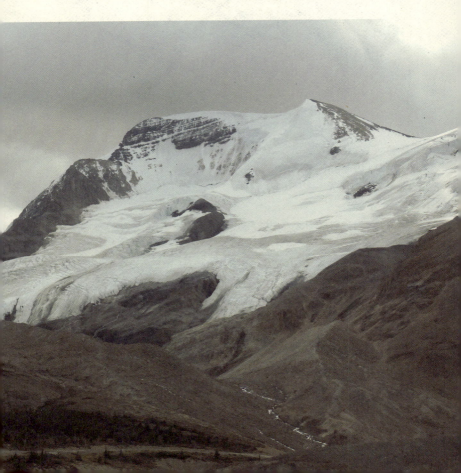

-27C and blowing snow
*we are still
here*, the muscle of water under thick ridge of ice
its engine idling

Owl lands on a vole
neither feels hunger anymore.

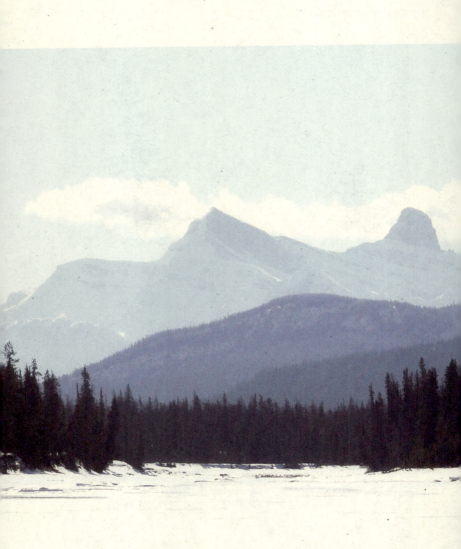

Painted the living room haint blue to keep away ghosts.
Wind rattled the glass bobs on the porch.
Light shivered through the house,
we are home.

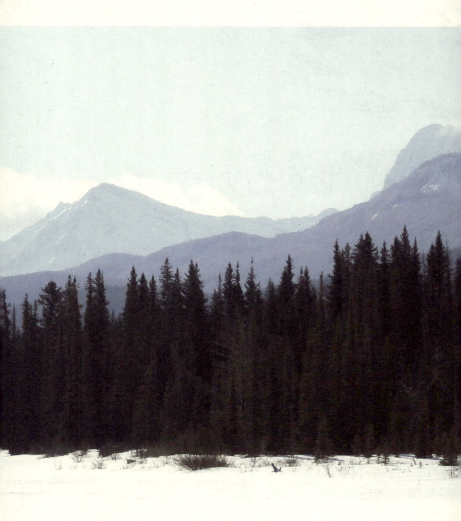

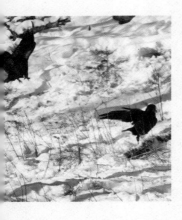

There are words on paper inked
on a screen somewhere, blinking
into someone else's eye, brain, heart.
Welcomed as a sandwich by a raven.

To be
the 4th pole in a tipi that
holds the door open –
purpose for our son.

When a coyote looks you in the eye
feral hearts jump fences.

I know all will break loose.
We drink or we drown.

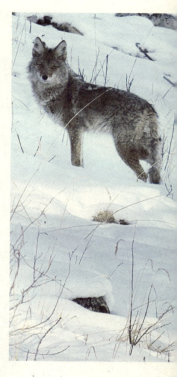

Never confuse luck
– catching ravens in flight –
with anything less than what it is
the privilege of seeing them home.

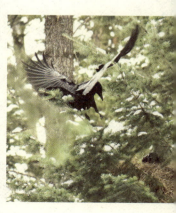

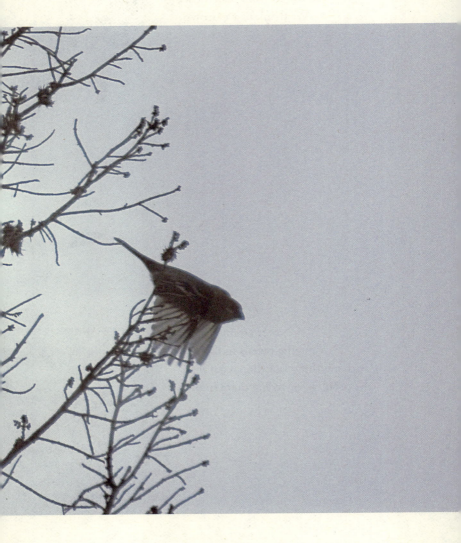

before a zoom presentation
there are birds
to remind me what zoom used to mean

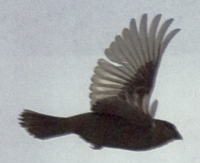

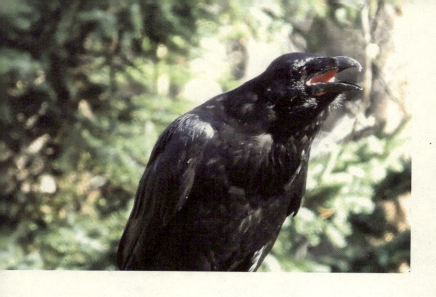

How to call a tree –

Rush forward with a willing heart to be of service.
Back away, with full love, when the offer is refused.

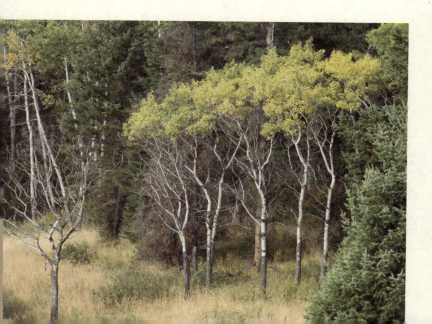

How to call weather –

Slip on the aurora stone ring
from Mémère and
a soft lavender scarf under your jacket.
Keep your stomach empty
whistle that tune your dad sang
on long car rides.

Abundance
I can't see the harm
and you can't see the reason.
Are we even looking at the same thing?

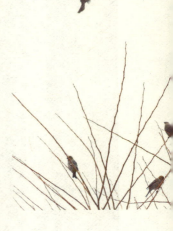

The world lurches and stumbles
while here the earth pulls free from winter
with wonder, with grace and certainty.

It is now and has always been
an arresting thing
this juxtaposition between
light and dark.

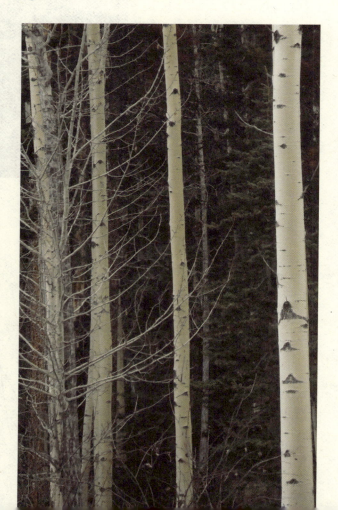

How to call geese –

Use equal amount moose velvet, sky and elk bugle.
Mix thoroughly against brisk spring wind.
Fling upwards in a clockwise motion as the moon sets.

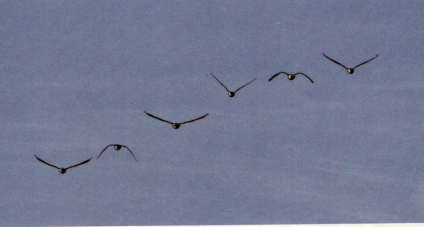

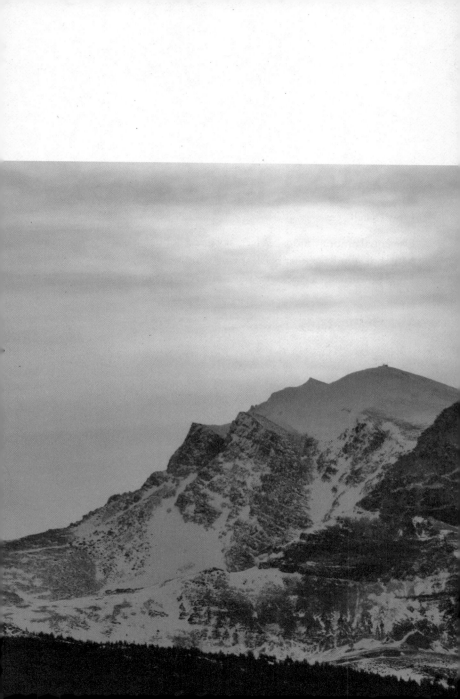

a year with Covid

Humans are weary and sad.
The earth
oh my! the light came and all was lit.

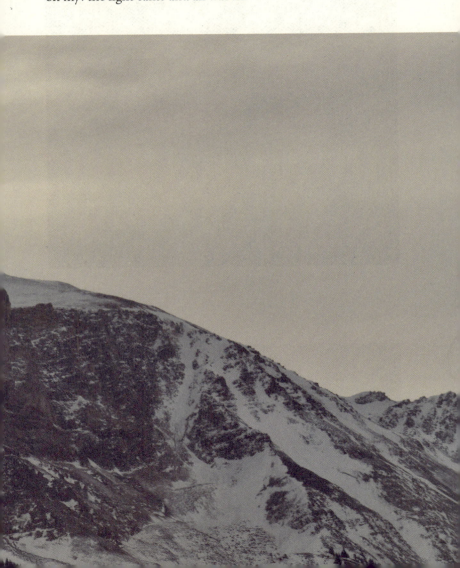

how we will save the world —
find a way

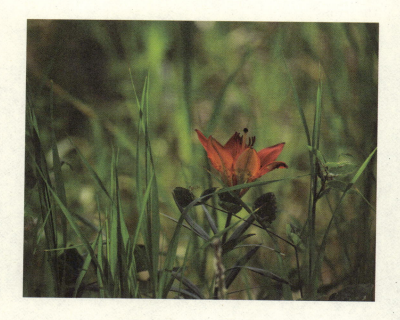

how we will serve the world

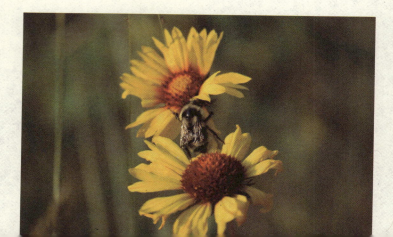

begin from here

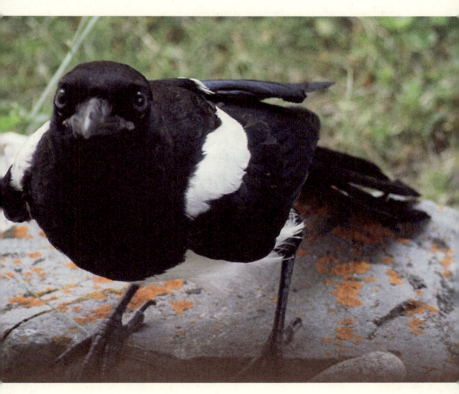

## sage bundles

for the land we learn from, marvel at and are solaced by – here in the Three Valleys Confluence, and the denizens of both field and forest moving in and out of Treaty 6 & 8 – a more sensible, cognisant and vital creation I can't imagine.

For the Guardians (Magda and Mark, Kathryn and Mark, Melissa and Keith Vicky and Mike).

Donal McLaughlin and Jerry Haigh, for your unfailing good humour and steadfast encouragement kept me going.

For Raymond and André, my life support system.

**Paulette Dubé** is a Jasperite who developed and presented sessions on topics such as sustainability, stewardship, responsibility and other environmentally sensitive driven topics for the Palisades Centre in Jasper National Park. As a French Immersion Humanities teacher, she adopted many trees in her lifetime and taught her students to do the same. Her poetry and prose have garnered a number of rewards and short list nominations including the Milton Acorn Memorial People's Poetry Award, the CBC Alberta Anthology, the CBC Literary Awards, the Alberta Writers' Guild Best Novel Award, the Starburst Award, the Exporting Alberta Award and the Fred Kerner Award. She was invited to the Banff Centre to present her poetry and insights into the necessity of nature for human beings and was recently named Writer-in-Residence at the Jasper Municipal Library.

OUR
AT BAY PRESS
ARTISTIC
COMMUNITY

Publisher
**MATT JOUDREY**

Managing Editor
**ALANA BROOKER**

Substantive Editor
**YVONNE BLOMER**

Copy Editor
**PRIYANKA KETKAR**

Proof Editor
**DANNI DEGUIRE**

Graphic Designer
**LUCAS C PAULS**

Layout
**LUCAS C PAULS AND MATT JOUDREY**

Publicity and Marketing
**SIERRA PECA**

Thanks for purchasing this book and
for supporting authors and artists.
As a token of gratitude, please scan the
QR code for exclusive content from this title.